Drawing Techniques

Discover Tons of Fun Ways to Draw and Color with Wax Crayons, Oil Pastels, and Colored Pencils!

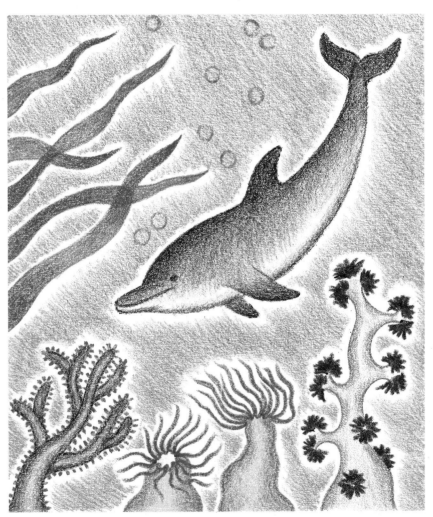

Illustrated by Diana Fisher

Tools and Materials

Here are all the supplies you'll want to have on hand to complete the exciting projects in this book!

OIL PASTELS

Oil pastels from Color & Co. come in packages of 12, 18, and 24 colors. These creamy, richly colored drawing tools are exceptionally smooth, providing easy and solid coverage. These pastels also blend together easily, making them perfect for color mixing.

WAX CRAYONS

Color & Co. has a variety of crayon sets available— you can purchase packages of 8, 16, 24, 48, or 64 different colors! These coloring tools are strong and resist breaking. Their smooth consistency allows them to glide easily over the paper, covering it quickly. And the crayons are sure to liven up your drawings with their amazingly bright colors!

Color & Co. offers art tools that make it easy to take those first steps into the world of creative self-expression. This company understands that the quality of artwork depends on the quality of the materials, so their products are made to exacting standards!

COLORED PENCILS

Color & Co. offers presharpened colored pencils in sets of 12 and 24, providing a variety of bright, vibrant colors to choose from. And the thick, strong leads of these pencils produce a soft texture, so it's easy to blend colors together and create a number of cool shades.

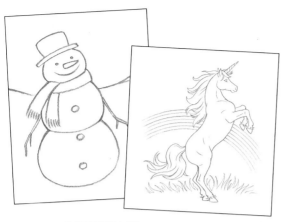

PATTERNS

Patterns for most of the projects in this book are on pages 31–40. Trace or transfer the images to your drawing paper.

PENCIL

To trace or transfer the patterns or to make your own freehand sketches, you'll need a sharp graphite pencil.

SHARPENER

Keep both your drawing pencil and your colored pencils clean and pointed with a handheld sharpener.

ERASER

Have an eraser nearby to correct any mistakes you've made with your graphite or colored pencils. But keep in mind that the eraser may not be able to completely remove the colored pencil.

EXTRAS

You'll also want to gather a few other supplies. You'll need scissors for cutting out stencils and a toothpick (or anything with a sharp point) for scraping. (See page 5.) Paper towels can be used to wipe your pastels clean—and to clean your hands after blending the pastels with your fingers. And paper towels are also good polishing tools for blending your crayon colors.

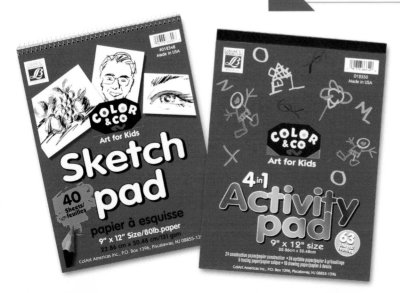

ART PAPER

To complete the projects in this book, you'll want to use drawing paper from an art supply store. Drawing paper is a bit thicker than regular paper, which is important when using heavy oil pastels. Color & Co. offers a variety of convenient art paper pads.

Getting Started

There are so many fun and exciting ways to draw and color with these terrific art tools! Before you begin the projects in this book, try a few of these cool techniques to discover a world of possibilities!

COLOR LIGHTLY

COLOR DARKLY

GRADATE

HATCH

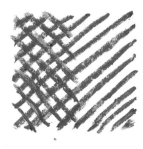

CROSS-HATCH

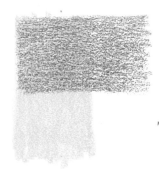

LAYER

CHOOSING PAPERS

Rough papers (left) will create more texture than smooth papers will (right). Although all three media will work on both types of paper, pastels tend to work best with a rough paper texture.

TRY THIS WITH COLORED PENCILS!

Use colored pencils to punch up another medium! First draw or paint your design with markers or watercolor paints. Then add the details with colored pencils.

Use a toothpick or any other tool with a sharp point to scratch out designs in your pastels, such as squiggles, lines, or hatch marks. This technique is called "sgraffito."

TRY THIS WITH OIL PASTELS!

TRY THIS WITH WAX CRAYONS!

Use the long, flat side of your crayon to create wide squiggly shapes. Or twist the crayon from side to side while keeping the center in one place on the paper.

Crayons: Stenciling

Grab your scissors and cut out some stencils to create this bubbly underwater scene!

Make your own stencil! Cut out a shape from a piece of paper, place it on another sheet, and color inside.

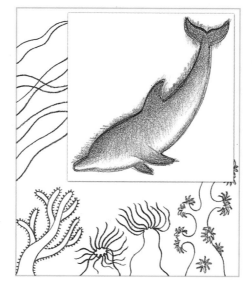

STEP 1

Trace the sea plants from the pattern onto your drawing paper. Then trace the dolphin onto a piece of scratch paper and cut it out. Place the dolphin stencil on top of your drawing paper and color inside the stencil with blue crayon.

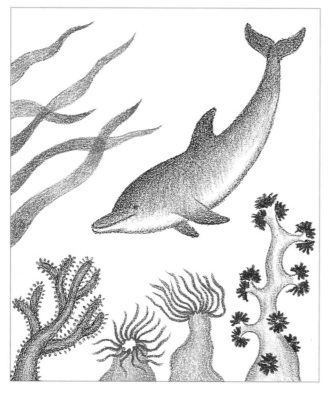

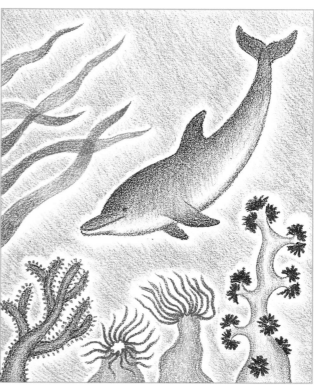

STEP 2

Next remove the stencil and begin coloring the coral and seaweed with bright, bold colors.

STEP 3

Color the water with light greens and blues, leaving white space around the objects to prevent smearing.

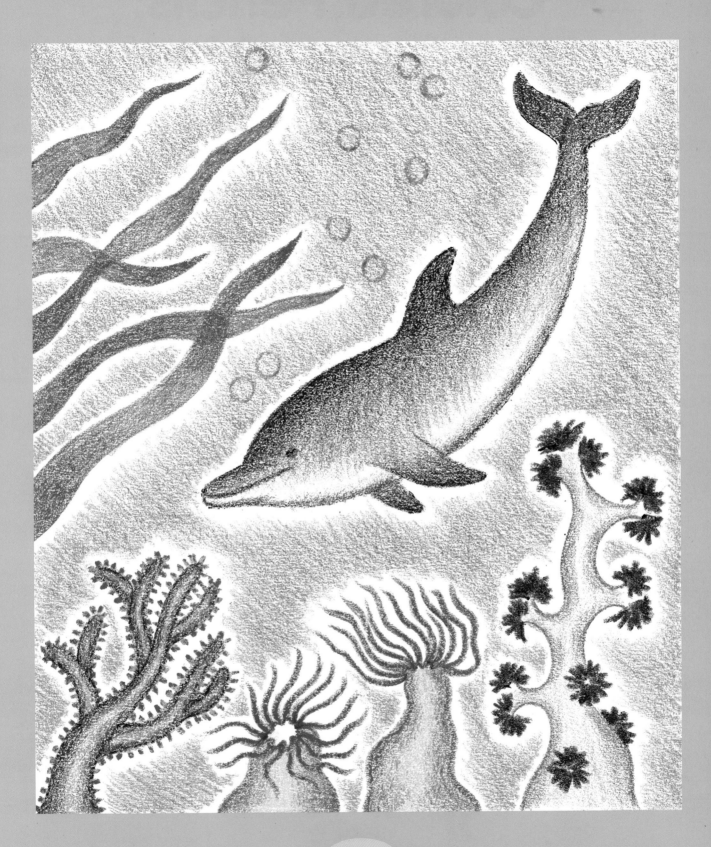

STEP 4

To finish your drawing, add a few bubbles by holding a light blue
crayon with the round, flat end on the paper and twisting it in place.

Colored Pencils: Cross-Hatching

Re-create this high-flying skateboarder with a cool and colorful cross-hatching technique!

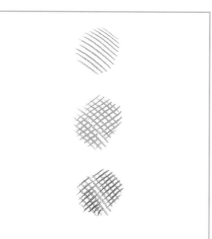

CROSS-HATCHING
This technique creates awesome shading and textures. Just draw parallel diagonal lines equally spaced apart; then cross over them with lines that slant in the opposite direction. Use two colors for an ultra-cool effect!

STEP 1

First draw a few guidelines as shown above to set up the basic position of the skateboarder.

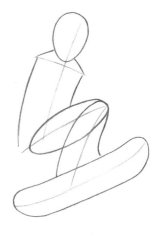

STEP 2

Now use the lines as guides to outline the board, right leg, and T-shirt. Place an oval for the head, as shown.

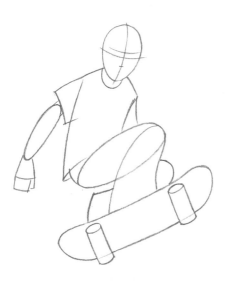

STEP 3

Add the shapes of the arms, legs, and wheels. Then mark the position of the eyes, nose, and helmet.

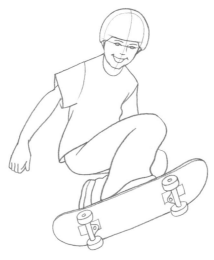

STEP 4

Draw the helmet and face details. Then clean up your outlines and erase any lines you don't need.

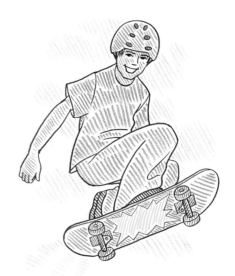

STEP 5

Now choose the colors you want to use and draw the first set of diagonal hatch marks!

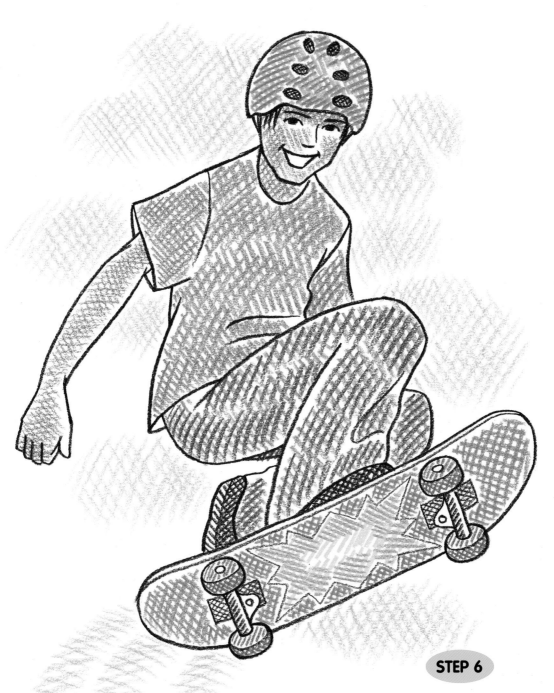

STEP 6

Finally add a second set of hatch marks in the opposite direction to complete this dynamic drawing. For a unique touch, draw your own original design on the skateboard!

Pastels: Pointillism

Use lots of dots and spots—a style called *pointillism*—
to bring these bright flowers into full bloom!

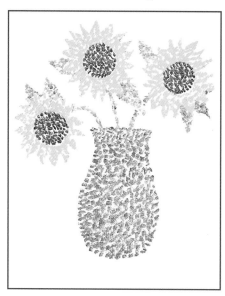

STEP 1

Trace the pattern onto your paper. Then press and
twist the tips of the pastels to dot on the lightest
colors of the flowers and the vase.

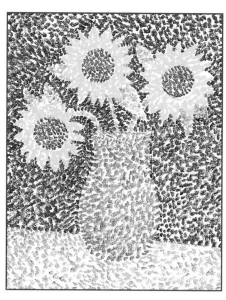

STEP 2

Using the same dotting technique (called
"stippling"), fill in the lightest shade of purple for
the background and dark yellow for the table.

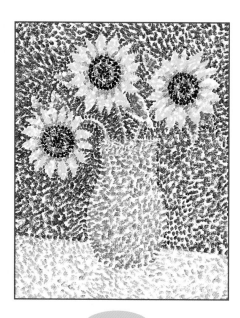

STEP 3

Add orange dots to the inner petals and darker
green to the leaves and stems. Stipple black into
the flower centers.

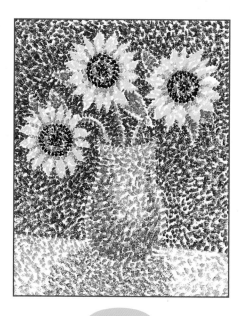

STEP 4

Then give your vase a 3-D look by stippling on purple
shadows. Create the shadow on the table with
brown dots. Then add dark blue to the background.

STEP 5

Finally give your drawing even more life
by adding black dots to the shadows and
the background.

Crayons: Scratchboard

Have a blast with easy-to-make scratchboard,
and create your own dino-rific scene!

STEP 1

On a sheet of paper, lightly draw a circle for
the head and an egg shape for the body.
Connect these shapes to form the neck.

STEP 2

After adding the muzzle and open
mouth, draw a circle and an oval
to position the arm and back leg.

STEP 3

Next draw the curving tail, two
arms, and lower legs. Don't forget
the eye and the nostril!

STEP 4

Add the teeth, claws, and details
to the face and limbs. Now place your
drawing over your final art paper,
with a stack of paper underneath.
Trace over your drawing, pressing
down firmly with your pencil.

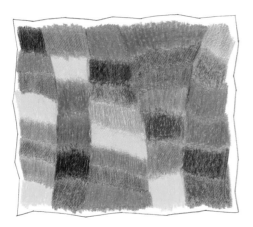

STEP 5

Now you have a dino indentation on the paper. Next cover the entire paper with patches of crayon.

STEP 6

Use a black crayon to color over the patches. Apply layer after layer until the whole page is black.

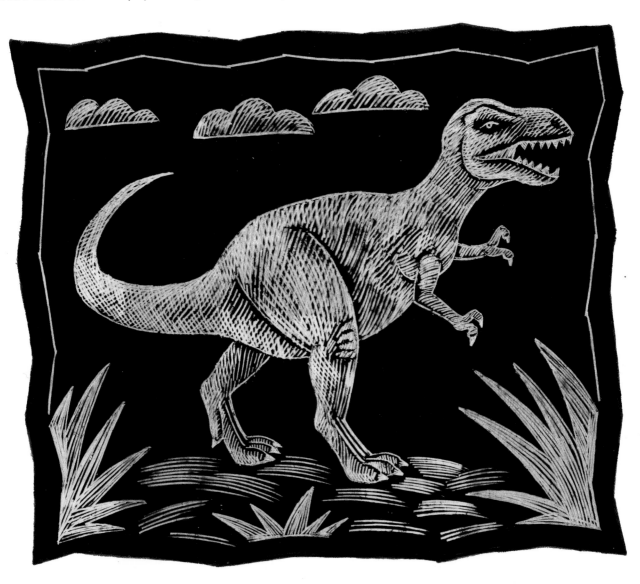

STEP 7 Then use a toothpick to trace over the indented outline of your dinosaur, scraping away the black to reveal the underlying colors!

Colored Pencils: Manga

Learn how to color this awesome manga character
with cool layers of vibrant colored pencil!

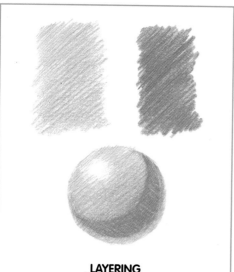

LAYERING
Although you can always create dark
colors by pressing firmly, you can also
build up darks by layering. Start with the
lightest colors; then layer darker ones on
top to create a variety of shades.

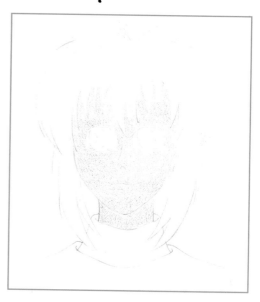

STEP 1

Trace the pattern. Then lightly layer orange
and pink to create the skin color for the face.

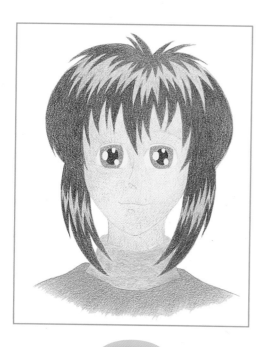

STEP 2

Then fill in the hair, eyes, and shirt with even layers
of color, drawing around the white highlights.

STEP 3

Now create shadows on the face and shirt using
darker layers of the same colors.

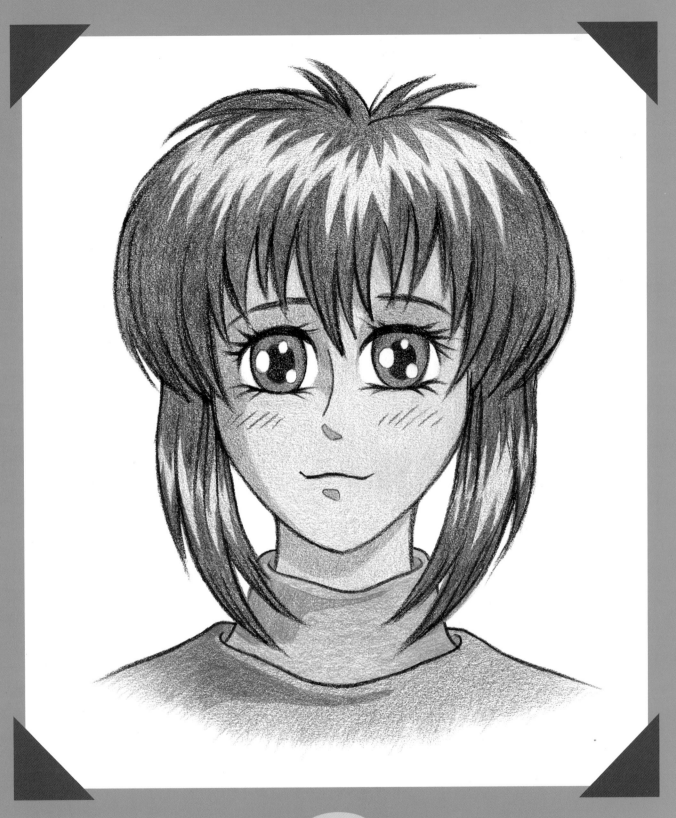

STEP 4

Give your character extra punch by outlining your drawing
in black colored pencil. To finish, add all the details to the
face, such as the eyelashes, eyebrows, nose, and mouth.

Pastels: Blending

Blend, smudge, and smear the colors to make this feather-soft tropical bird!

FEATHERING
Place two colors side by side, overlapping them slightly in the middle. Then rub across both colors with your finger or a paper towel to softly blend them. (You can also buy a paper blending stump at your local art supply store.)

STEP 1

Trace the pattern. Then scribble on a few shades of green to suggest leaves, coloring around the bird.

STEP 2

Next use a paper towel or your finger to rub over the oil pastels, smoothing out the strokes.

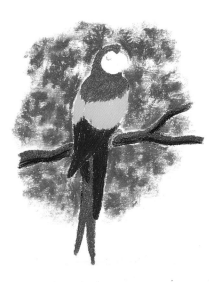

STEP 3

Then fill in the body of the bird with red, yellow, and blue. Use brown and black for the branch.

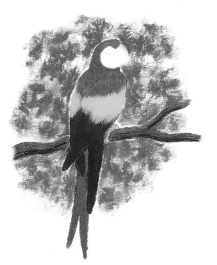

STEP 4

Now blend these colors together where they meet to give the body a soft and feathery look.

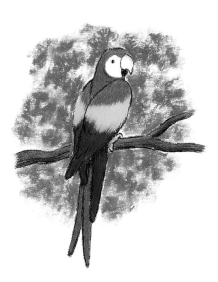

STEP 5

Use a black oil pastel to add the eye and the beak and to outline the bird with short dashes.

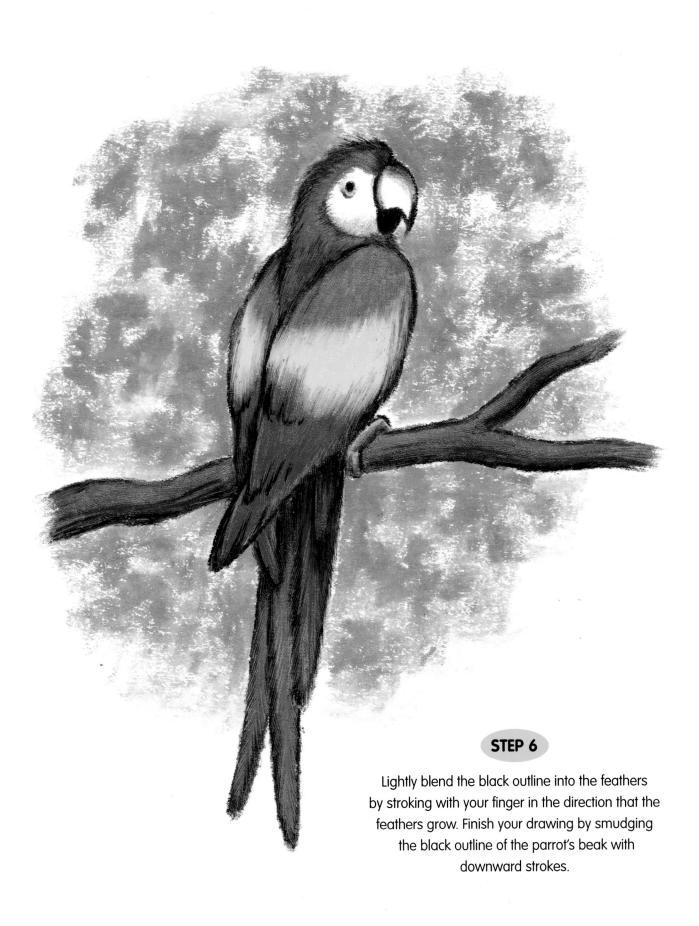

STEP 6

Lightly blend the black outline into the feathers
by stroking with your finger in the direction that the
feathers grow. Finish your drawing by smudging
the black outline of the parrot's beak with
downward strokes.

Crayons: Impressionism

Color this cute Kitty with small patches of colors—the way the Impressionists do—to make your drawing light and airy!

LOOSELY BLENDING
Instead of rubbing the colors together to blend them, place patches of different colors next to each other. When you look at the drawing from a distance, the colors will seem to blend together!

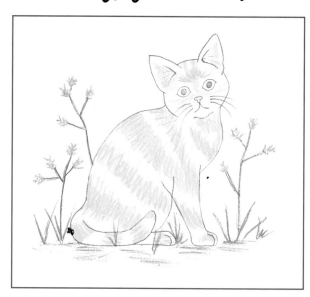

STEP 1

After tracing the pattern, apply short strokes of yellow for the kitten. Then add pink for the flowers and green for the grass. Keep it light, with lots of white spaces!

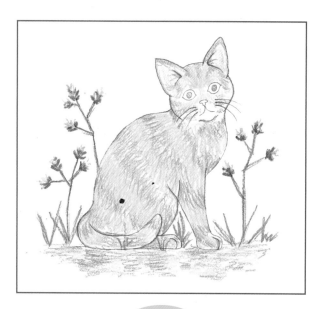

STEP 2

Next add some medium shades to the drawing. Apply orange to the cat and red to the flowers. Then add scribbles of blue and yellow to the grass.

STEP 3

Now layer on even darker colors. Use blue crayon for the flowers, grass, stems, and sky. Then add brown to the kitten's coat.

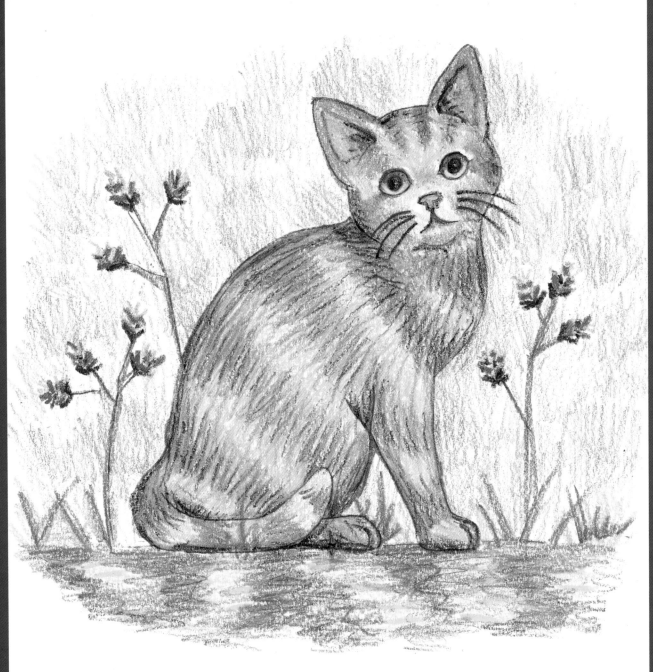

STEP 4

To finish this Impressionistic cat, use black crayon to
create the darkest accents. Then fill in the details,
such as the nose, mouth, and eyes.

Colored Pencils: Layering

Let your imagination run wild as you draw this
rearing unicorn by layering colored pencils!

First lightly trace the pattern onto your paper and color the fantasy rainbow, overlapping each color into the next. Make sure to color around the shape of the unicorn.

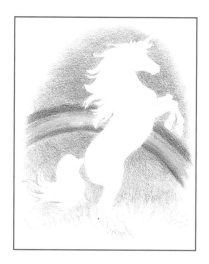

Now fill in the sky with light blue, still coloring around the unicorn. Press evenly and stroke in the same direction to create a smooth background.

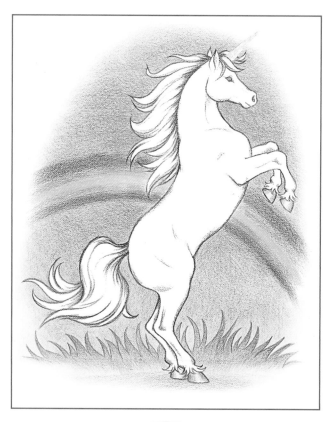

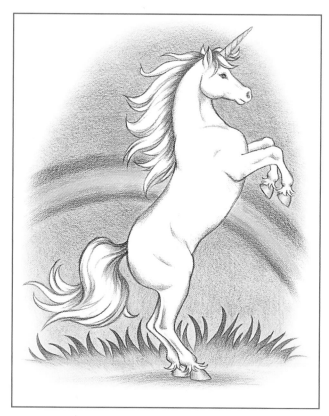

STEP 3

Outline the unicorn with a purple pencil. Then color the horn yellow and the grass yellow-green.

STEP 4

Shade the ridges of the horn with a brown pencil. Next apply a layer of dark green over the grass.

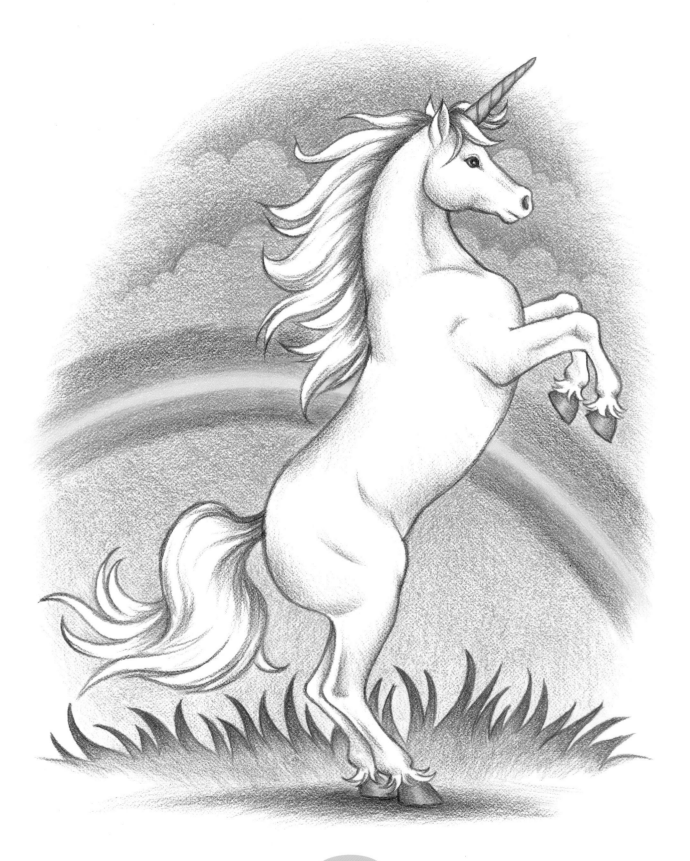

STEP 5

Now add some pink highlights to the unicorn's body and stroke blue in the tail and mane. Then place clouds in the sky by layering purple over the blue. Finally color in the unicorn's hooves!

Pastels: Colored Paper

Bring this lovable pup to life with oil pastels on colored art paper—and see how the dark background makes it really "pop!"

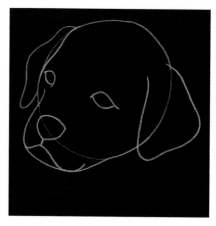

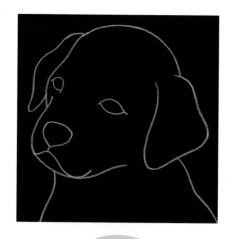

STEP 1

With a white oil pastel or colored pencil, draw a circle for the head and outline the muzzle.

STEP 2

Then add the details of the face, including the pup's ears, eyes, nose, and mouth.

STEP 3

Now draw the body with lines that meet the center of the ear and the center of the chin.

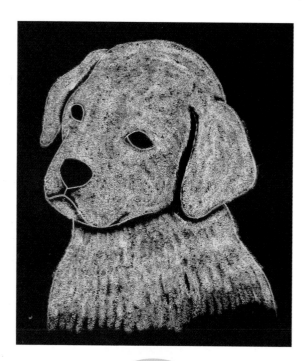

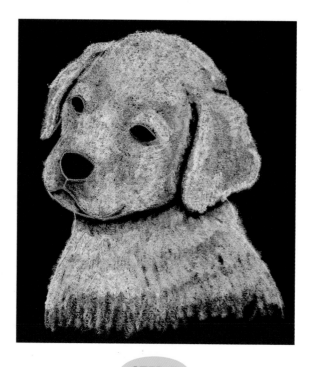

STEP 4

Use a dark yellow oil pastel to fill in between the lines, leaving a gap between the ears, body, and face.

STEP 5

Choose a lighter shade of yellow to color highlighted areas on the dog's coat and give it a soft shine.

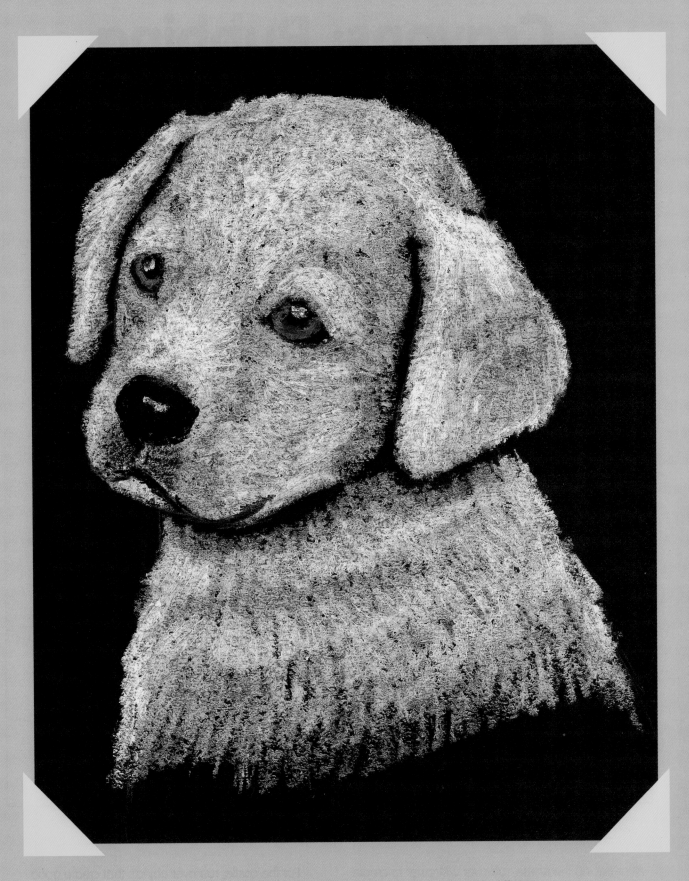

STEP 6 Fill in the top of the nose and the eyes with different shades of brown, leaving the pupils the color of the paper. Then use a white oil pastel to add the lightest highlights to the nose, eyes, and eyebrows.

Crayons: Rubbing

Create cool textures for this crayon Kingdom by taking rubbings of a variety of objects!

MAKING A RUBBING

First collect some flat objects that have interesting shapes and textures, such as leaves, lace, bracelets, buttons, paper clips, kitchen strainers, and place mats. (You can cut shapes you need, such as stars, out of thick paper.) Place the items under your drawing paper. Then just rub over them with crayons to make cool textures on your drawing.

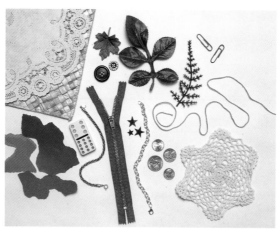

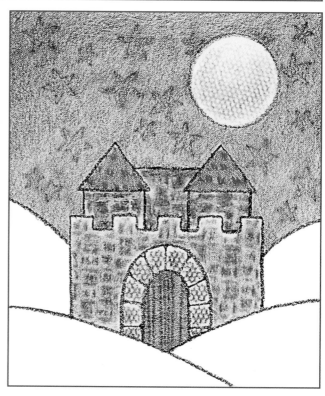

STEP 1

After tracing the scene, rub over a strainer to create the moon texture. Place star shapes under your paper and rub over the sky with the side of a blue crayon.

STEP 2

For the castle, rub over objects that create good textures for the wall, door, and arch, such as netting, wood, or a woven place mat.

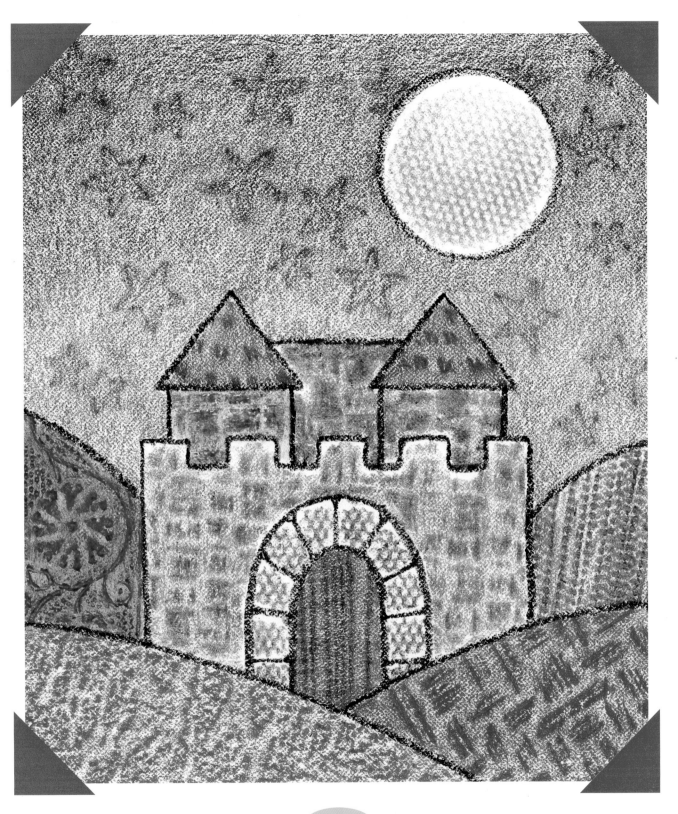

STEP 3

Next fill in each hill by rubbing over a different object
with green and blue crayons. Now you have a night
scene that glows with texture!

Colored Pencils: Burnishing

Give this super-hot sports car a shiny red paint job by burnishing with colored pencils!

STEP 1

Trace the pattern and then add the base colors to the car using a purple pencil for the body and black for the air scoops.

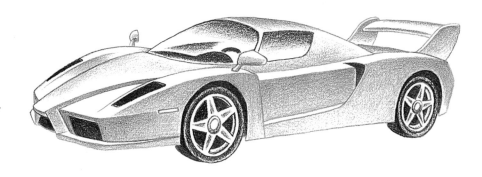

STEP 2

Now use black to color the tires, rims, steering wheel, dashboard, and top areas of the windows.

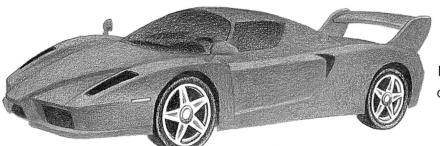

STEP 3

Next add layers of red to the body and blue to the windows, pressing harder for the darkest areas.

BURNISHING

Burnishing is a way of blending colors by using a lot of pressure, making them super smooth and shiny. Start with a base color; then, using firm pressure, go over it with a lighter color, such as yellow or white.

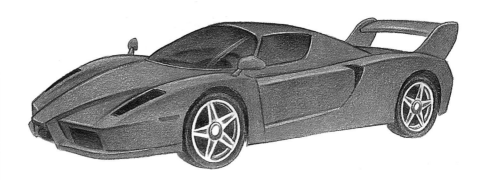

STEP 4

Burnish the body with both yellow and white colored pencils, stroking quickly with plenty of pressure. Then burnish the windows with gray and the tires with white.

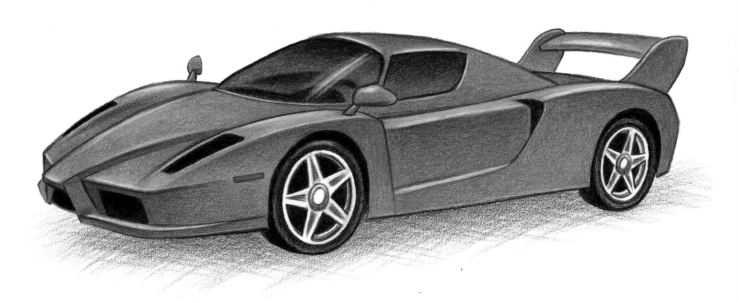

STEP 5

To finish, use a toothpick to scratch off some of the colored pencil for highlights on the car's body and windshield. Then, using the cross-hatching technique, add a shadow beneath the car with blue. Now your shiny new car is ready to roll!

Pastels: Coloring White

Don't be fooled into drawing with just your white pastel—make this winter wonderland with purples, blues, and pinks!

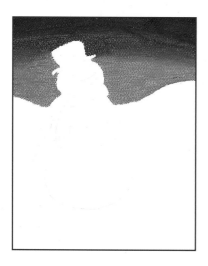

STEP 1

After tracing the pattern, cover the sky with thick layers of blue pastel. Start with dark blue at the top, making it gradually lighter as you move toward the bottom.

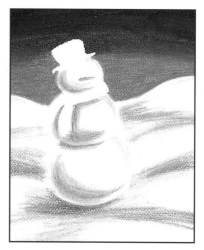

STEP 2

Add shadows to the snow using purple, pink, and blue. Then color the snow with a white pastel to cover the paper and blend the shadows.

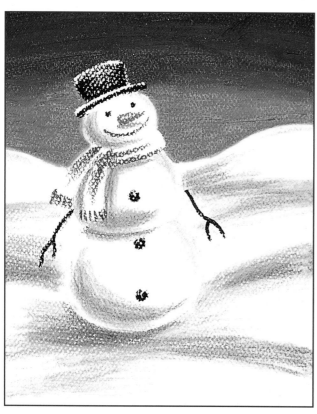

STEP 3

Next add black buttons, eyes, and arms. Lightly color the hat, nose, and scarf—and don't forget his smile!

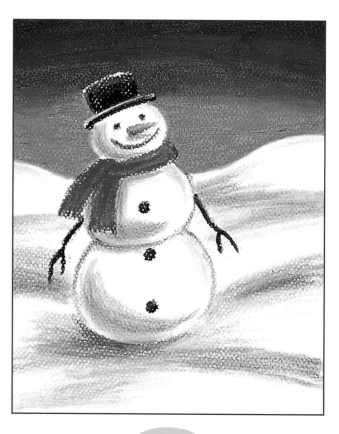

STEP 4

Now add pink to the scarf and yellow to the nose. Smooth out the scarf, nose, and hat with your finger.

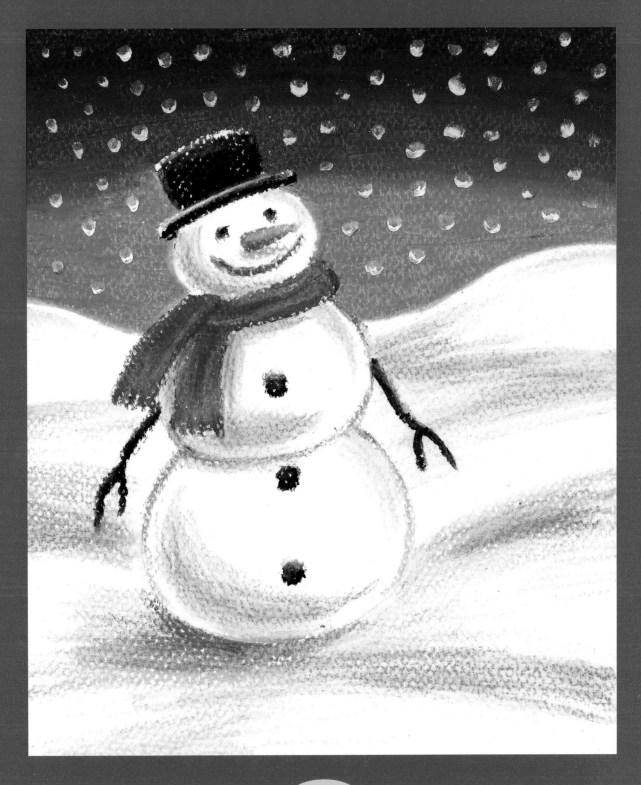

STEP 5

To complete this snowy scene, add snowflakes
by pressing and twisting the end of your white
pastel stick onto the sky.

Mixed Media

After you've tested every technique in this book, try using colored pencils, crayons, and oil pastels all in one drawing!

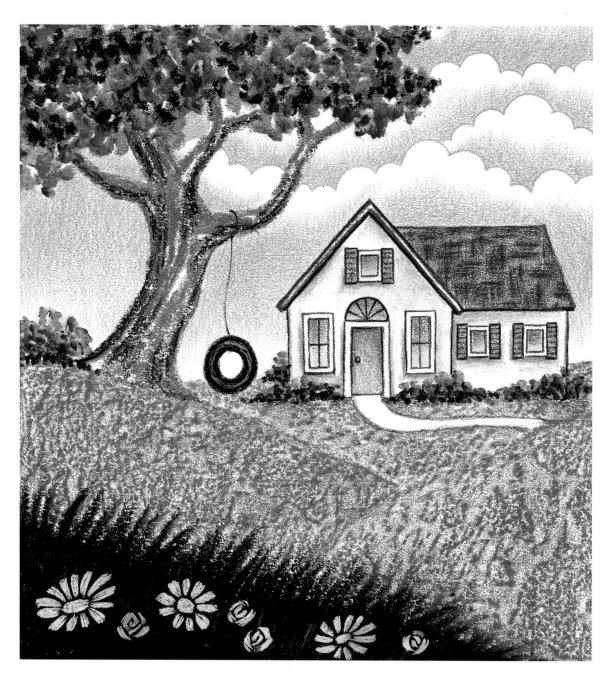

The picture above shows how combining all three drawing tools can result in a stunning work of art. Now look at the picture carefully and see if you can point out the techniques you've learned about in this book, such as using scratchboard with wax crayons, stippling with oil pastels, and layering with colored pencils!

Patterns

Lightly trace or transfer these line drawings onto art paper; then use them as guidelines for the projects in the book.

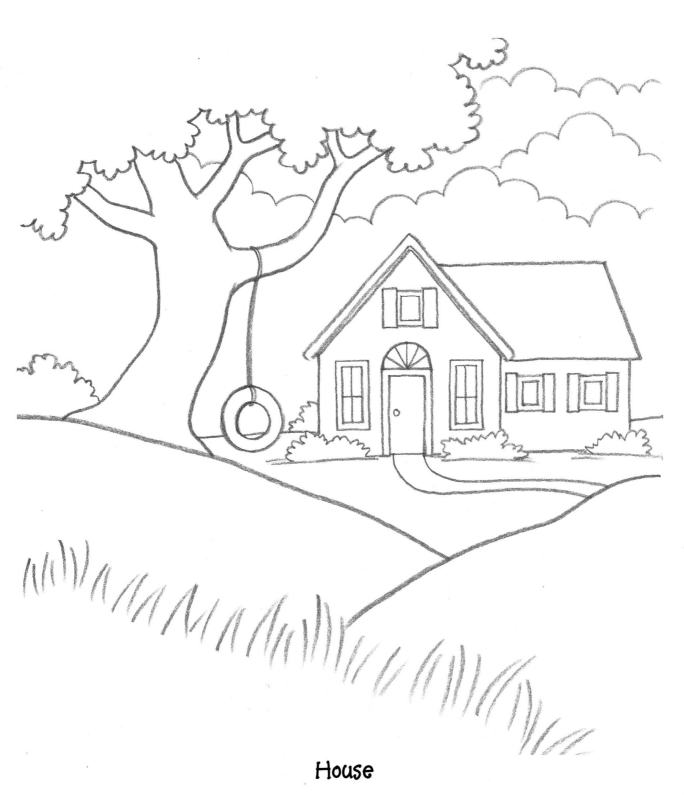

House

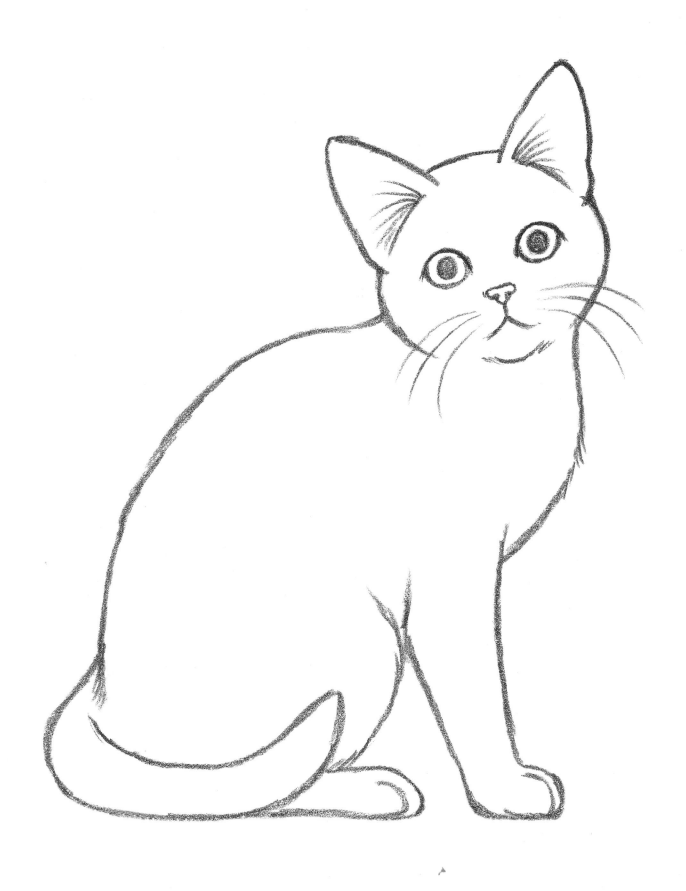

Kitten

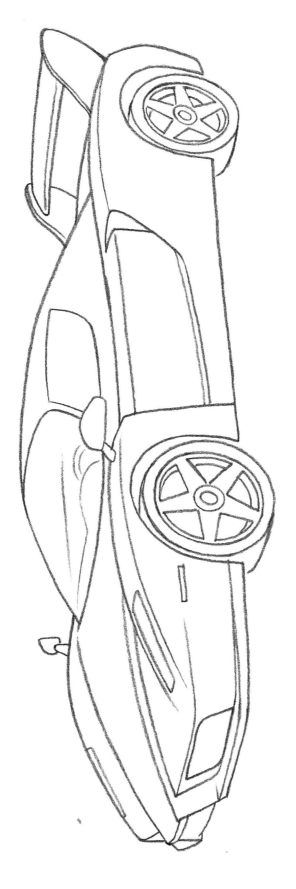

Racecar

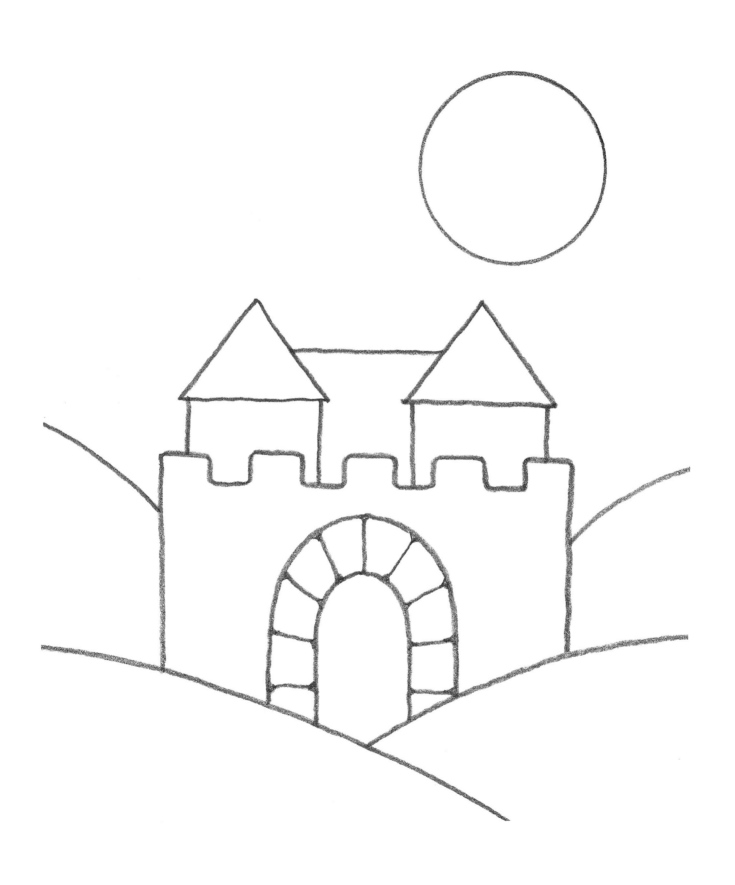

Castle

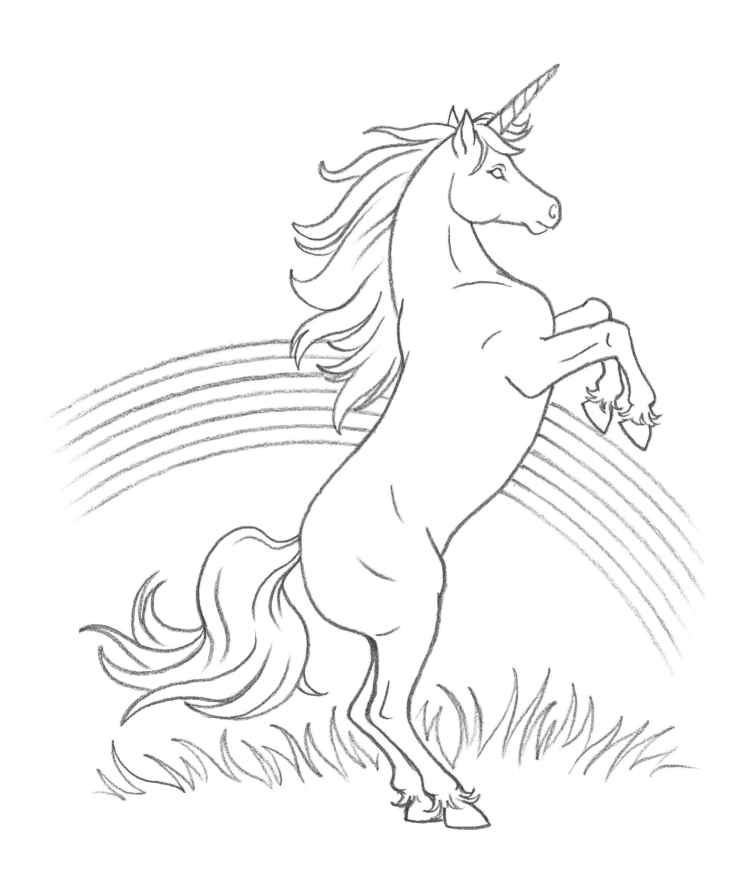

Unicorn

Parrot

Snowman

Manga

Dolphin

Sunflowers